T0299623

THE DO-IT-YOURSELFIE GUIDE

THE ULTIMATE SELFIE GUIDE
TO CAPTURE THE BEST VERSION OF YOURSELF

WILLEM POPELIER

B/S

SELFIE

A PHOTOGRAPH THAT ONE HAS TAKEN OF ONESELF, TYPICALLY ONE TAKEN WITH A SMARTPHONE OR WEBCAM, AND SHARED VIA SOCIAL MEDIA.

SECTIONS

I

GENERAL CONDITIONS

RULES 1 - 5

USE A CAMERA (TYPICALLY A SMARTPHONE OR WEBCAM).

TAKE A PHOTO OF YOURSELF. DON'T GIVE THE CAMERA TO ANYBODY ELSE.

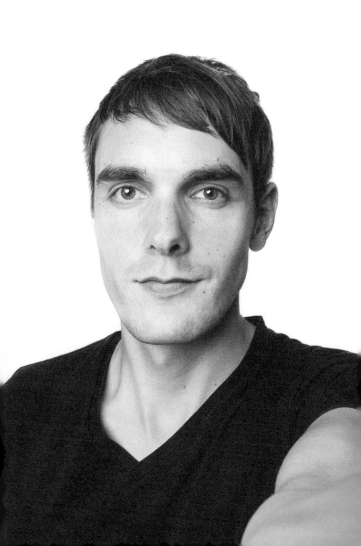

<u>#3</u>

THE PHOTO HAS TO
LOOK SPONTANEOUS.

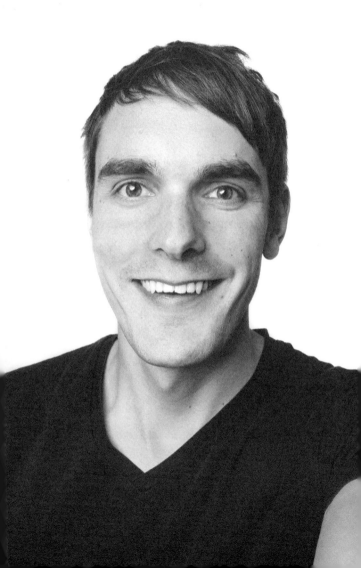

PRACTICE AND BE PATIENT.

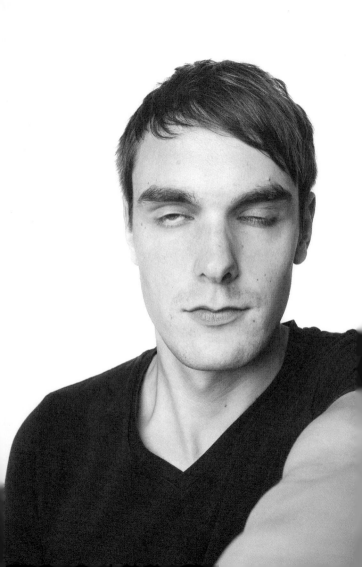

DON'T CONFUSE SELFIE WITH SELF-CENTERED.

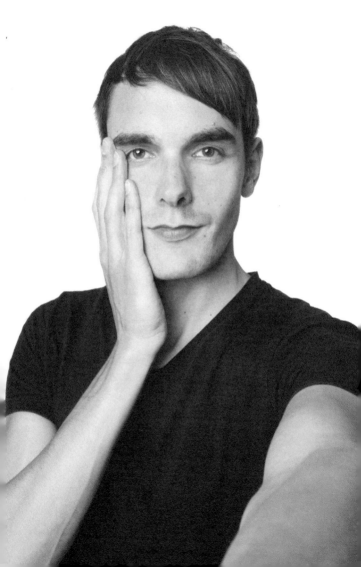

II

CAMERA

RULES 6 - 11

#6

USE A HIGH RESOLUTION CAMERA TO OPTIMIZE DIGITAL ENHANCEMENT, OR USE A LOWER RESOLUTION SO YOUR SKIN WILL LOOK SOFT AND MORE EVEN.

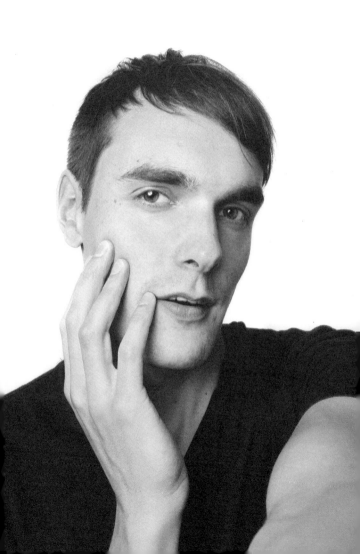

<u>#7</u>

HOLD YOUR CAMERA VERY STILL TO AVOID BLURRINESS.

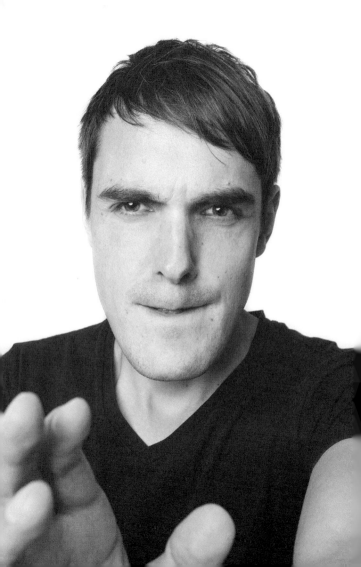

USE YOUR WRIST TO POINT THE CAMERA TOWARD YOUR FACE.

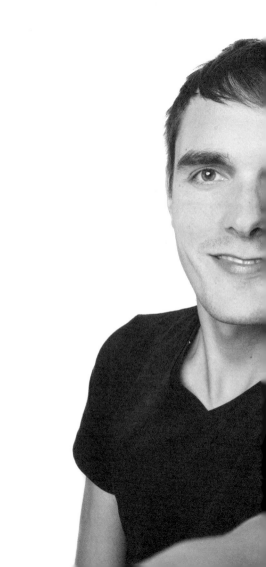

PRACTICE USING BOTH YOUR RIGHT AND LEFT HAND TO TAKE SELFIES.

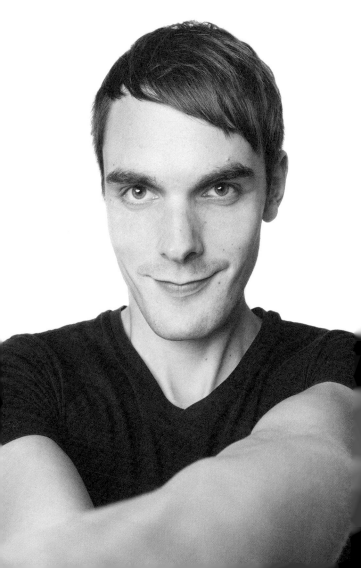

WHEN USING A TOUCHSCREEN, TOUCH THE DARKEST OBJECT IN THE PICTURE FRAME.

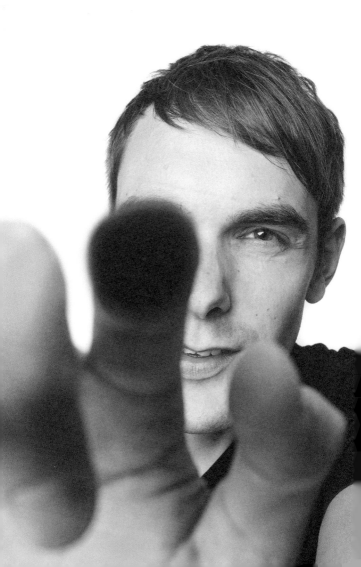

#11

WHEN TAKING GROUP SHOTS ALWAYS USE A FRONT-FACING CAMERA.

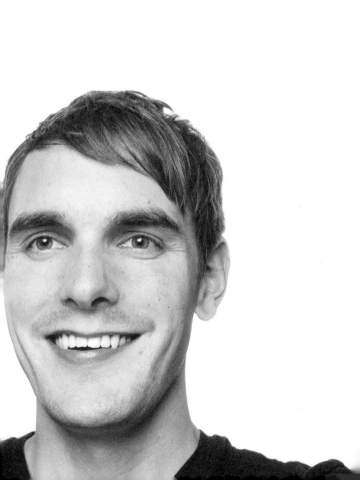

III

LIGHT

RULES 12 - 16

NATURAL LIGHTING IS THE BEST LIGHT FOR PICTURES, SO TAKE YOUR SELFIE NEAR A WINDOW OR OUTDOORS.

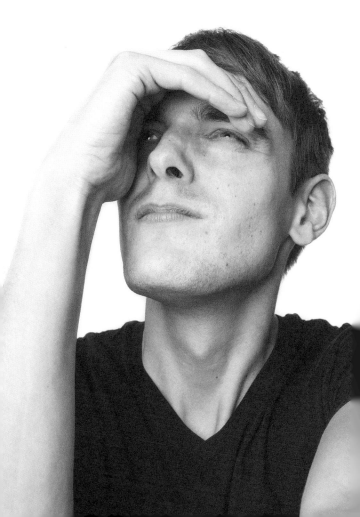

<u>#13</u>

KEEP THE SUN OR OTHER LIGHT SOURCE IN FRONT OF YOU, A BIT ABOVE EYE LEVEL.

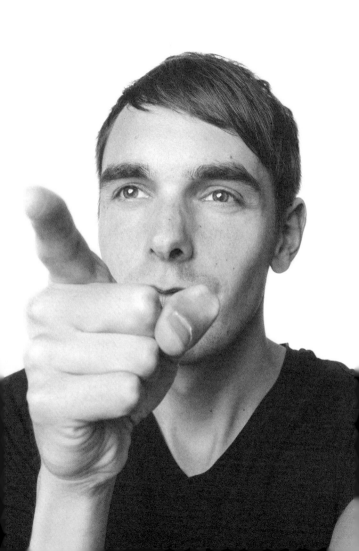

THE BEST LIGHT FOR A SELFIE IS DURING TWILIGHT.

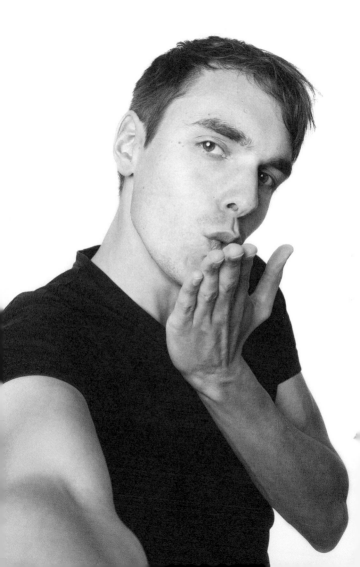

#15

DON'T TAKE SELFIES DURING LUNCHTIME. LUNCHTIME SUN IS THE WORST SELFIE LIGHT.

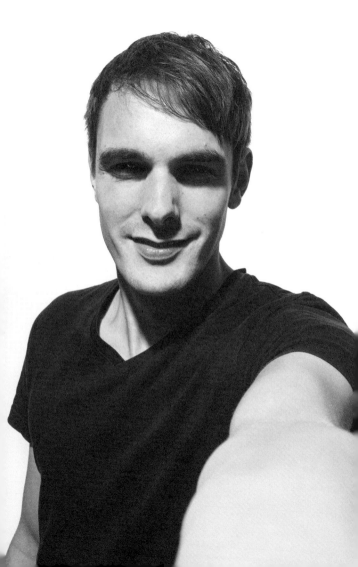

DON'T USE YOUR FLASH.

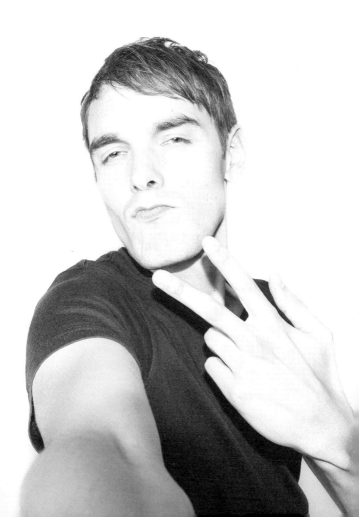

IV

DISTANCE

RULES 17 - 18

USE A LONG ARM.

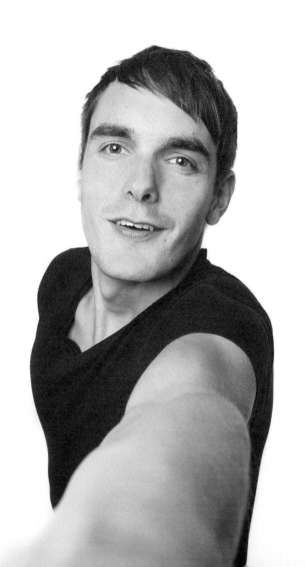

#18

DON'T HOLD THE CAMERA TOO CLOSE.

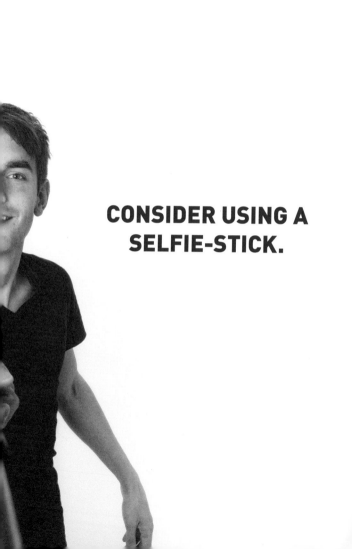

CONSIDER USING A SELFIE-STICK.

V

ANGLE

RULES 19 - 23

KNOW YOUR "GOOD SIDE". IT'S THE SIDE OF THE FACE THAT LOOKS THE MOST BALANCED AND SYMMETRICAL. ALWAYS USE THAT SIDE FOR SELFIES. GENERALLY THE GOOD SIDE IS THE LEFT CHEEK.

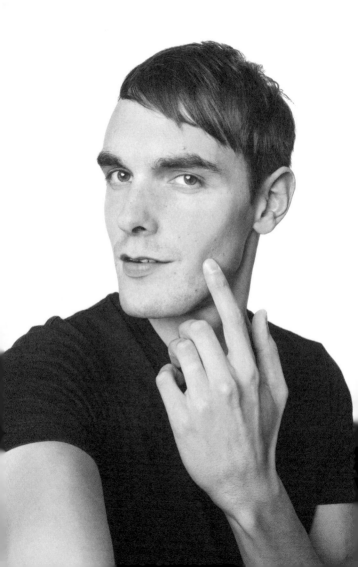

TURN YOUR FACE AT A 3/4 ANGLE, THE UNIVERSAL GOOD SELFIE ANGLE.

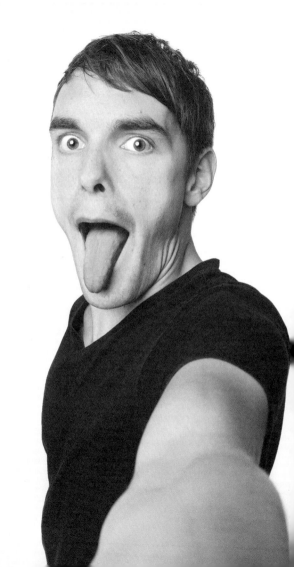

#21

DON'T TURN YOUR HEAD MORE THAN 30 DEGREES IN ANY DIRECTION.

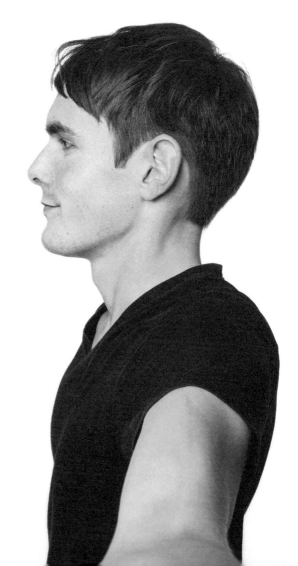

HOLD THE CAMERA UP, ABOVE EYE LEVEL, THE BEST LEVEL FOR PICTURES.

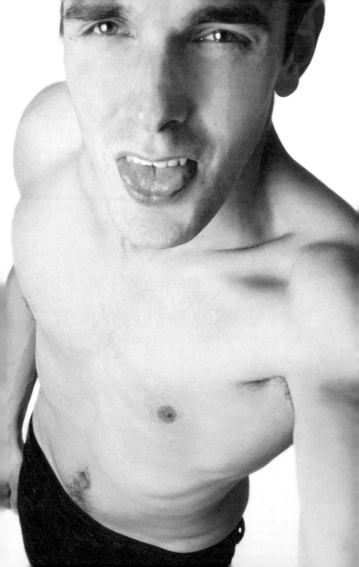

DON'T HOLD THE CAMERA VERY LOW OR VERY HIGH. TRY ANGLING IT UPWARD ABOUT 10 DEGREES.

VI

FACIAL
EXPRESSION

RULES 24 - 27

HAVE AN
INTERESTING
FACIAL EXPRESSION.

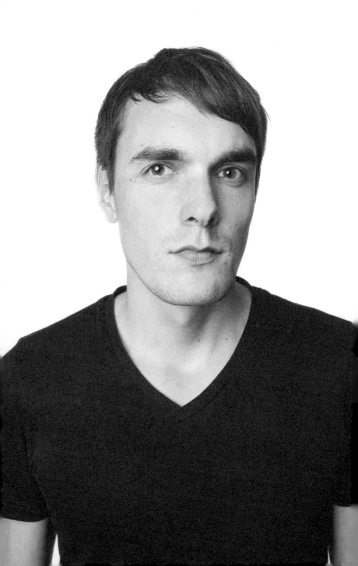

CAPTURE YOURSELF WHEN YOU'RE FEELING AN EMOTION.

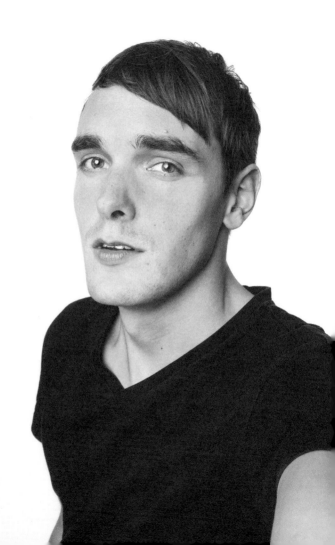

PLAY AROUND WITH DIFFERENT SMILES. A SMILE IS ONE OF THE MOST APPRECIATED AND CHARMING EXPRESSIONS YOU CAN WEAR.

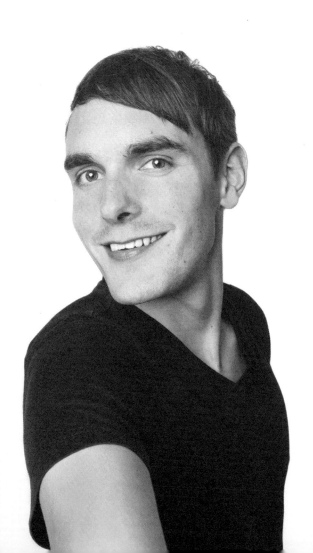

KNOW WHICH EXPRESSIONS ARE CONSIDERED PASSÉ. SOME BECAME WILDLY POPULAR AND ARE NOW WELL PAST THEIR PRIME.

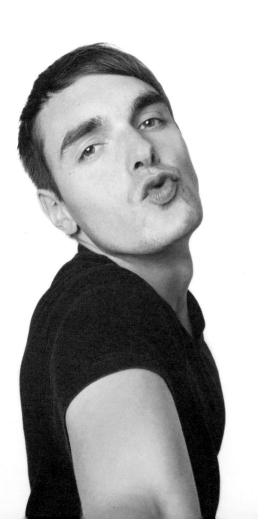

VII

<u>POSE</u>

RULES 28 - 35

ACT CONFIDENT.

#29

ELONGATE YOUR NECK.

LEAN TOWARDS THE CAMERA SLIGHTLY WITH YOUR HEAD FIRST.

TO APPEAR SLENDER COCK YOUR HIP AND JUT THE OTHER SHOULDER FORWARD. YOUR FREE ARM CAN DANGLE AGAINST YOUR BODY, UNLESS YOU ARE WEARING A SLEEVELESS SHIRT, IN WHICH CASE THE HAND SHOULD BE PLACED ON THE HIP. THE CHEST SHOULD LEAN FORWARD NATURALLY, AND THE LEGS SHOULD BE CROSSED AT THE ANKLE.

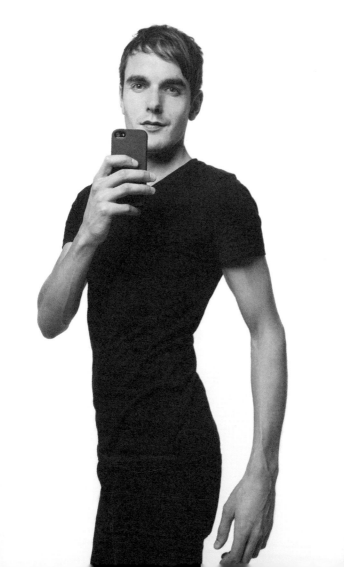

CLEAVAGE SHOWS WELL IF YOU PROP YOURSELF UP WITH ELBOWS IN A BED OR ON THE FLOOR.

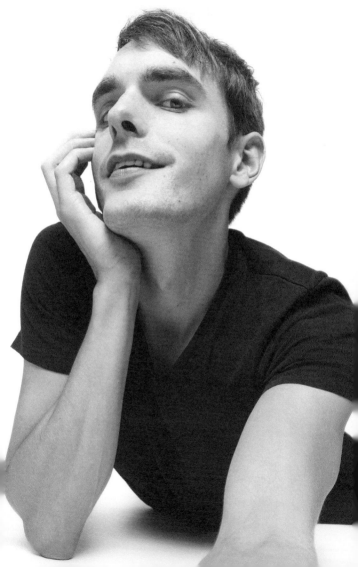

ABS LOOK BEST TAKEN FROM THE SIDE. LEAVE THE SHIRT RIGHT OFF, IT'S BETTER THAN PULLING IT UP, WHICH LOOKS SLOPPY AND HALF-HEARTED.

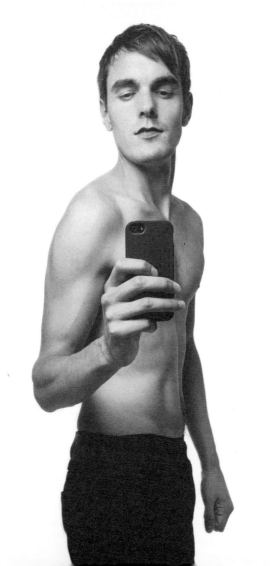

IF YOU HAVE MUSCLES, SHOW THEM.

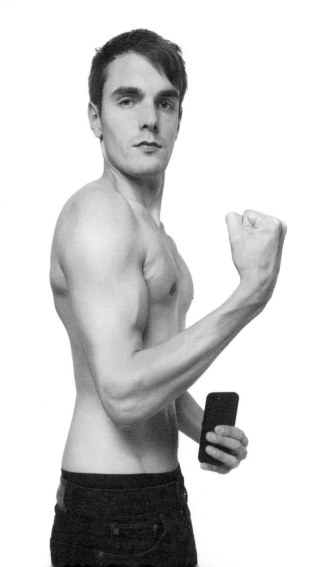

IF YOU'RE NOT KIM KARDASHIAN, DON'T TAKE A PHOTO OF YOUR BOTTOM ("BELFIE").

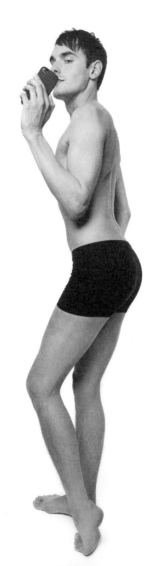

COMPOSITION

RULES 36 - 44

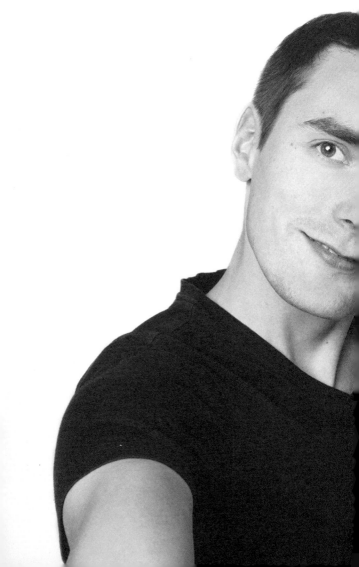

TAKE PHOTOS HORIZONTALLY. SOME PEOPLE LOOK BETTER IN A LANDSCAPE COMPOSITION.

TAKE PHOTOS VERTICALLY IF YOU WANT TO SHOW YOUR FULL BODY.

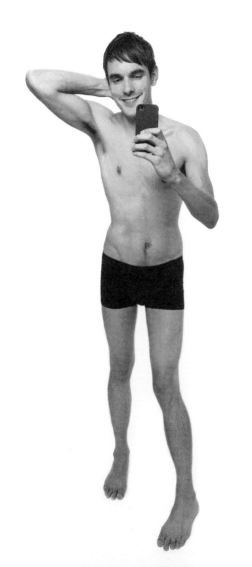

A TILTED ANGLE GIVES A MORE SPONTANEOUS LOOK.

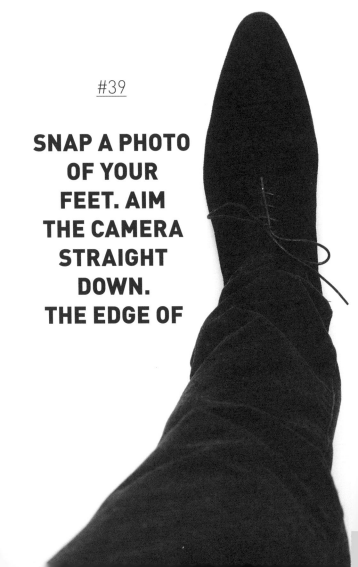

SNAP A PHOTO OF YOUR FEET. AIM THE CAMERA STRAIGHT DOWN. THE EDGE OF

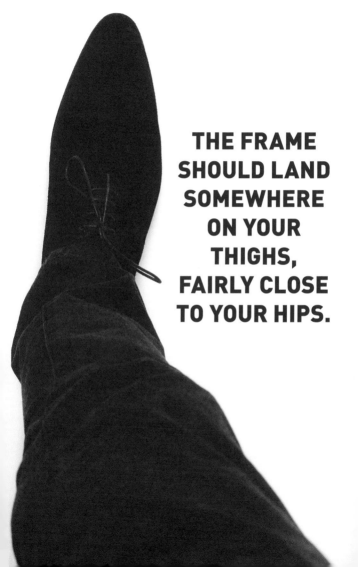

THE FRAME SHOULD LAND SOMEWHERE ON YOUR THIGHS, FAIRLY CLOSE TO YOUR HIPS.

YOUR FACE IS THE PRIORITY, NOT ANY OTHER BODY PARTS.

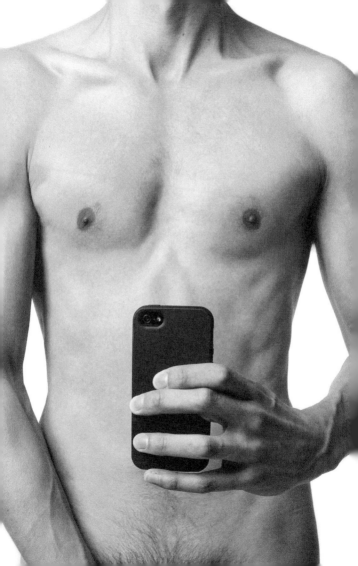

DON'T USE A MIRROR UNLESS THERE'S NO OTHER WAY TO GET THE SHOT YOU WANT.

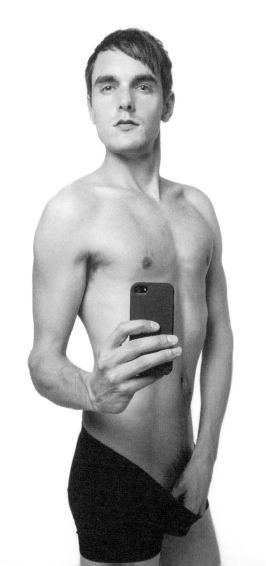

TAKE A SELFIE HOLDING SOMETHING.

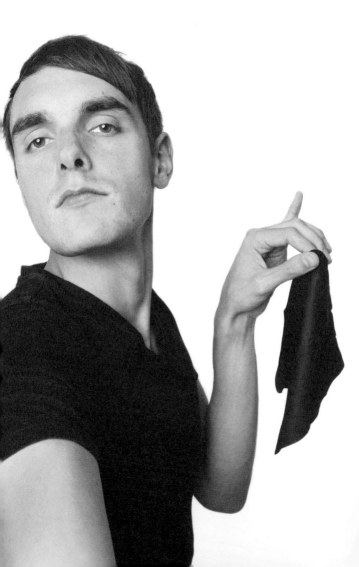

#43

**SHOW OFF WITH
SOMETHING NEW.
MAKE SURE THAT
YOU FRAME THE
PHOTO IN A WAY
THAT HIGHLIGHTS
THE NEW FEATURE.**

#44

OFFSET YOUR FACE SO THERE'S ROOM IN THE FRAME TO CAPTURE THE SCENERY.

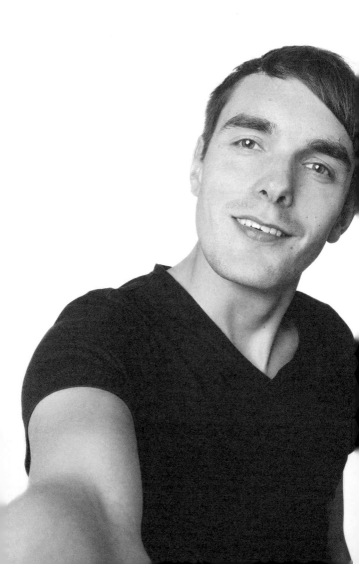

IX

LOCATION

RULES 45 - 54

MAKE SURE THE LOCATION IS IN THE FRAME IF YOU'RE SOMEWHERE SPECIAL.

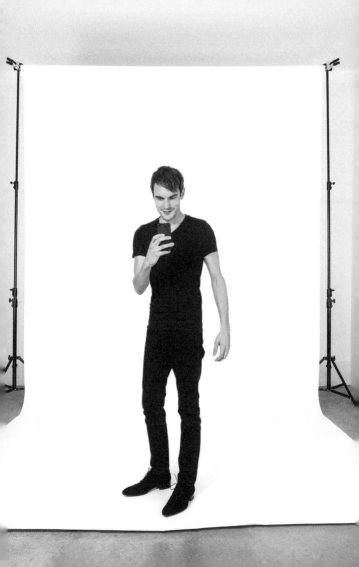

POSITION YOURSELF SO THAT YOU'RE IN FRONT OF THE BACKGROUND YOU WANT PEOPLE TO SEE.

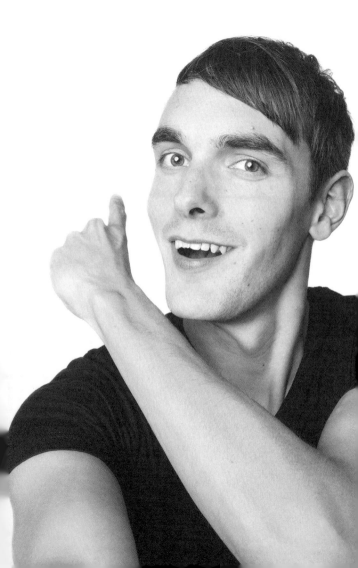

#47

NATURE ALWAYS MAKES A GREAT BACKGROUND.

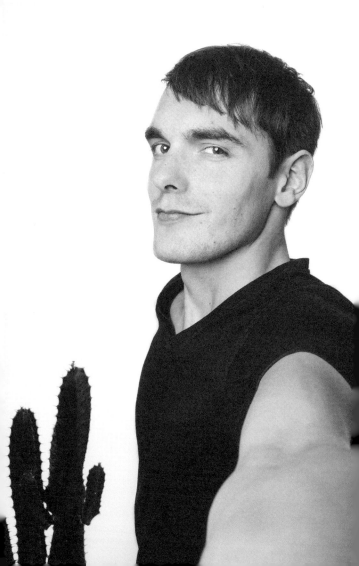

STAY INDOORS AND TAKE A SELFIE IN YOUR ROOM.

#49

TAKE FULL BODY SHOTS IN A CLUTTER-FREE SPACE.

TAKE SELFIES ON YOUR HOLIDAY.

#51

POSE IN FRONT OF
THE MONA LISA.

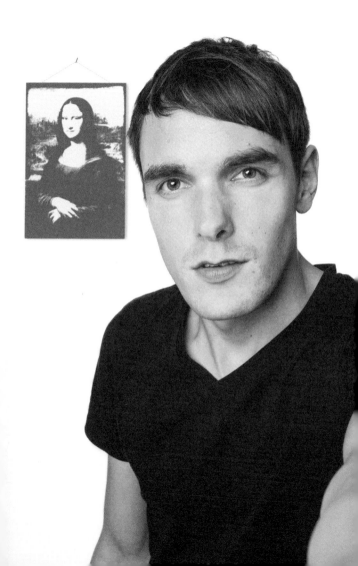

TAKE A SELFIE IF YOU MEET SOMEONE FAMOUS.

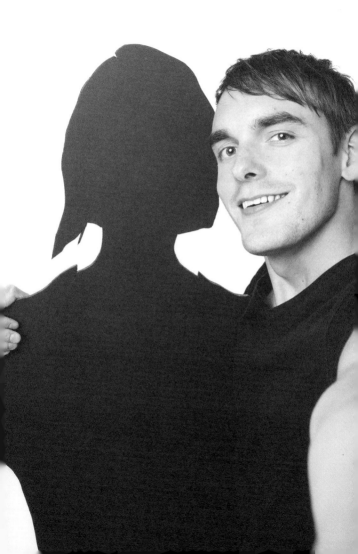

WATCH OUT FOR PHOTO-BOMBERS.

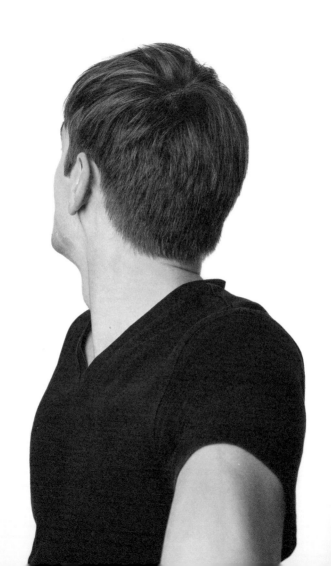

#54

**MAKE SURE
THE SETTING IS
APPROPRIATE.
SOME PLACES ARE
REGARDED AS
OFF-LIMITS TO
SELFIES.**

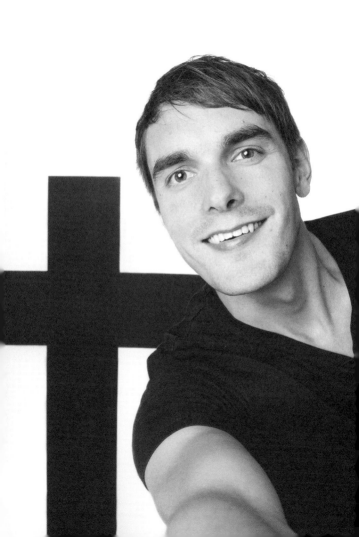

X

EDIT

RULES 55 - 58

HAVE AN APP THAT CAN ADD AN INTERESTING DIMENSION THROUGH THE USE OF COLOR AND LIGHT FILTERS.

EXPERIMENT WITH FILTERS. PLAY AROUND WITH DIFFERENT OPTIONS BEFORE SETTLING ON THE BEST ONE.

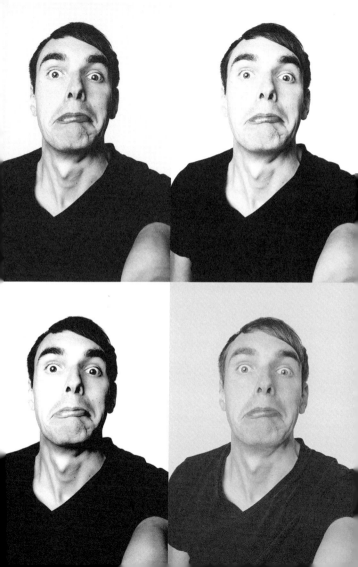

IF YOU OWN PHOTO-EDITING SOFTWARE, TOUCH UP ANY BLEMISHES OR FLAWS ON THE SELFIE.

#58

USE PHOTO EDITING SPARINGLY.

XI

SHARE

RULES 59 - 66

AFTER TAKING SELFIES, CHOOSE THE BEST ONE TO POST ON THE INTERNET.

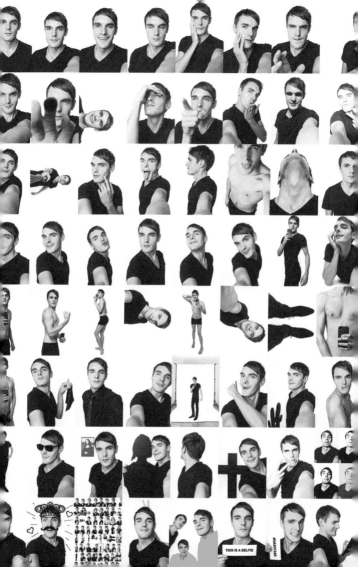

#60

**DOUBLE-CHECK
THE BACKGROUND
THOROUGHLY FOR
PHOTO-BOMBERS
BEFORE YOU UPLOAD
THE SELFIE.**

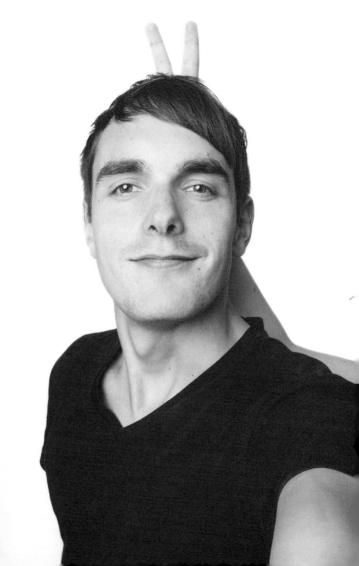

GET MORE PEOPLE IN THE PICTURE TO GET THE SELFIE SHARED MORE.

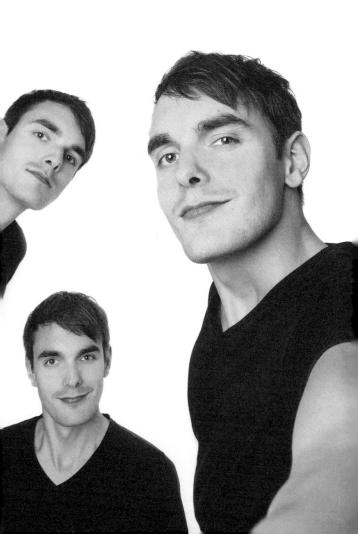

ADD A CAPTION TO
DESCRIBE WHAT'S
HAPPENING IN THE
PICTURE.

THIS IS A SELFIE

USE HASHTAGS.

PUBLISH THE SELFIE ON A POPULAR SOCIAL MEDIUM.

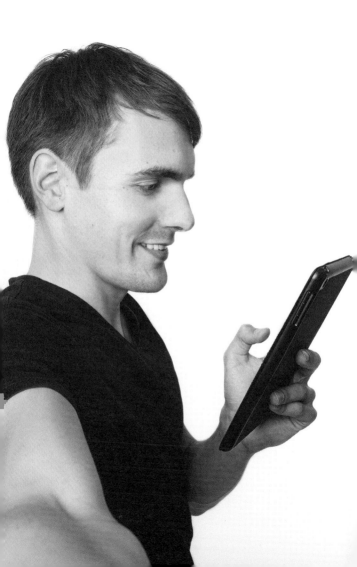

GIVE LIKES AND SHARES TO OTHERS TO GET LIKES AND SHARES YOURSELF.

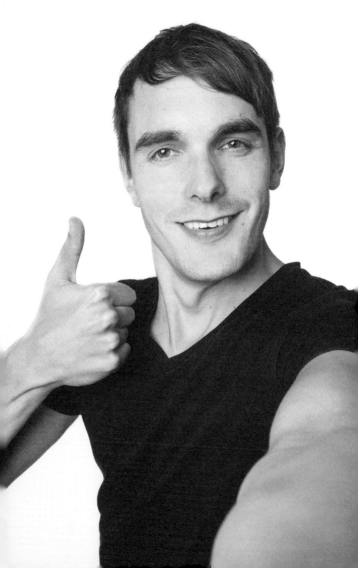

SOMETIMES A
SPECIFIC SELFIE
TREND WILL SWEEP
SOCIAL MEDIA. LOOK
OUT FOR INTERESTING
HASHTAGS AND JOIN
THE TREND.

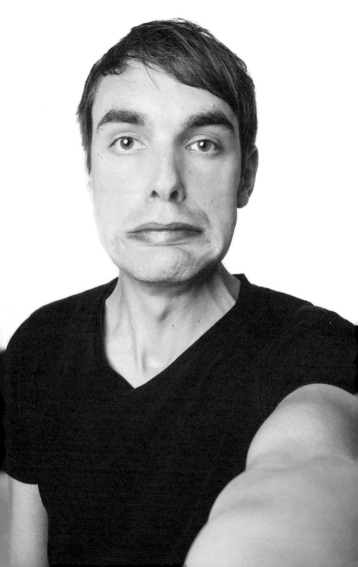

THE DO-IT-YOURSELFIE GUIDE
WILLEM POPELIER

WWW.WILLEMPOPELIER.NL
THEOBVIOUSPORTRAIT.TUMBLR.COM

SPECIAL THANKS TO MY WIFE NIENKE.

THANKS FOR YOUR SELFIES
JUSTIN BIEBER, THE CHAINSMOKERS, BRADLEY COOPER, ROBERT
CORNELIUS, MILEY CYRUS, ELLEN DEGENERES, P. DIDDY, EMINEM,
KIM KARDASHIAN, BEYONCÉ KNOWLES, DOUTZEN KROES,
BREANNA MITCHELL, MICHELLE OBAMA, SASHA OBAMA, HELEEN
VAN ROYEN, SIERRA, BENNY WINFIELD JR., AND MANY, MANY,
MANY MORE SELFIE TAKERS.

THANKS FOR YOUR TIPS, THOUGHTS AND RESEARCH
SCOTT AYRES, TINA BAINE, NICOLA BRUNO & MARCO BERTAMINI,
TERESA BÜCKER, CLARKIIE, LAURA CUMMINS, BRIAN DROITCOUR,
WOES VAN HAAFTEN, JAZZY, NIMROD KAMER, HEATHER KELLY,
SARAH KEMBER, KILLER1223, KEES VAN KOOTEN, LOLITZSARAH,
KALEB MANYWELE, CHARLES DANIEL MCDONALD, ARLYN NELSON,
NOWSOURCING, OXFORD ENGLISH DICTIONARY, MICHELLE PHAN,
NIRAJ RAVAL, THIJS REMMERS, ERIN GLORIA RYAN, ANNA SCHRAM,
RIK SCHUTTE, THE SELFIE NATION, THE SELFIES RESEARCH
NETWORK, ROBERTO SCHMIDT, RACHEL SIMMONS, THATSOJACK,
SYLVAIN VRIENS, GILLIAN WEARING, AND MANY MORE.

SUPPORTED BY THE MONDRIAAN FUND.

BIS PUBLISHERS
BUILDING HET SIERAAD
POSTJESWEG 1
1057 DT AMSTERDAM
THE NETHERLANDS
T +31 (0)20 515 02 30
BIS@BISPUBLISHERS.COM
WWW.BISPUBLISHERS.COM

ISBN 978 90 6369 387 9